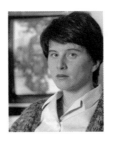

# FIONA TAN

# COUNTENANCE

With an essay by Mark Godfrey

MODERN ART OXFORD

2005

## PREFACE

Fiona Tan works within the contested territory of representation: how we represent ourselves and the mechanisms that determine how we interpret the representation of others. Photography and film – made by herself, by others, or a combination of both – are her mediums; research, classification and the archive, her strategies in skilfully crafting moving and intensely human works that explore history and time and our place within it.

Within the interconnecting narratives that she weaves into her work, Tan takes on the dual persona of "the traveller and the anthropologist"[1], simultaneously revealing her own impressions and self-consciously questioning their very validity. Her adeptness in handling her material becomes a sympathetic reflection of questions with which we ourselves, as viewers, are faced; questions about who we are and how we are categorised define in turn how we recognise and define those around us.

First presented at *Documenta 11* in Kassel in 2002, the multi-channel installation of *Countenance* holds in tension themes central to Tan's work. Drawing on August Sander's vast photographic project, *Citizens of the Twentieth Century* (1910-1964), in which he attempted to capture a social portrait of Germany in the first half of the century, Tan created around ninety minutes of filmed portraits of some two hundred and fifty citizens of Berlin. While subtly signalling the historical

[1] Lynne Cooke, 'Fiona Tan: Re-Take', in *Scenario: Fiona Tan*, Mariska van den Berg and Gabriele Franziska Götz (eds.), vandenberg&wallroth, Amsterdam, 2000, p. 21

resonance of the work within the contemporary reality of a re-unified Germany and an increasingly mobile Europe, Tan also inverted and created new and less clear-cut relationships between subject and viewer. Tan's lucidity of purpose is matched by the respectful tentativeness of her declared approach: *Could I possibly [..] collate a time in history?* And if it were possible, *Whose History?* As Mark Godfrey points out in his original and illuminating essay written for this publication, doubt is the very stuff of Tan's project with which she confronts contemporary ways of seeing.

For her exhibition at Modern Art Oxford, Tan presents *Countenance* (2002) alongside two subsequent works: *News from the Near Future* (2003), a meditation on water, time and memory which she has constructed from footage found in Amsterdam's Filmmuseum archive, and *Vox Populi* (2004) – a photographic installation which presents a vast collection of photographs from family albums collected by Tan in Norway. Tan presents us with a richly textured 'Tree of Life' in which the enduring themes of birth, adolescence, old age and death are played out across multiple generations.

We are greatly indebted to Fiona Tan for agreeing to show such an important body of work in Oxford, and for her engagement with the exhibition and publication.

The exhibition at Modern Art Oxford and this publication have been generously supported by the Mondriaan Foundation, Amsterdam and the Royal Netherlands Embassy, London, for which we are enormously grateful. Their support is an important acknowledgement of Tan's work and the significant place it holds in contemporary visual art.

Jane Hamlyn has been instrumental in the success of this project, for which we thank her. We also thank her colleagues at Frith Street Gallery, Charlotte Schepke, Dale McFarland and Karon Hepburn who provided their assistance and advice in the planning of the exhibition.

We are grateful to Mark Godfrey for his insightful essay on *Countenance*, which offers a new contribution to the already impressive bibliography on Tan's work. For the design of this book, we extend our fullest thanks to Gabriele Franziska Götz who worked with great sensitivity and in close collaboration with the artist.

Finally, our thanks goes to our colleagues at Modern Art Oxford who have worked with their usual energy, intelligence and passion in bringing Fiona Tan's work to a broader public.

Suzanne Cotter | Andrew Nairne

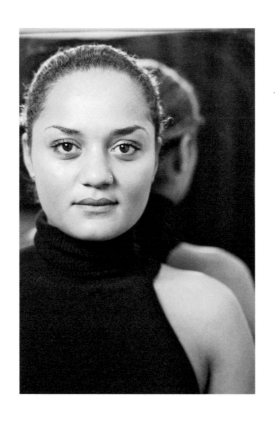

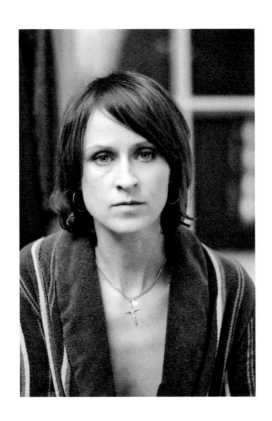

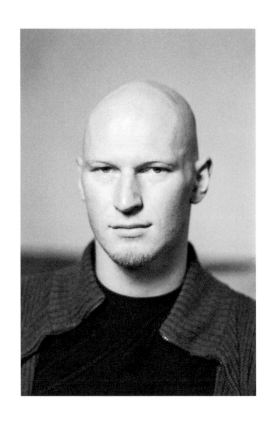

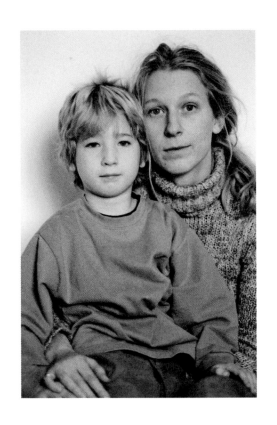

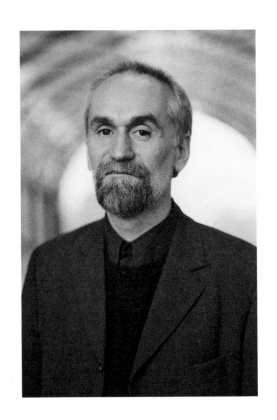

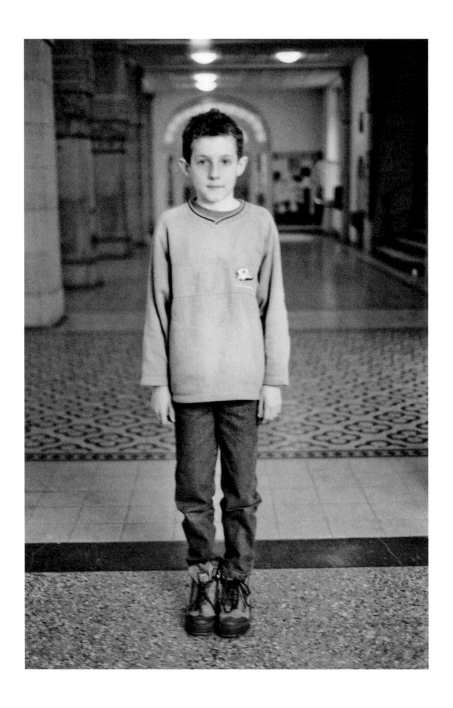

*Child*

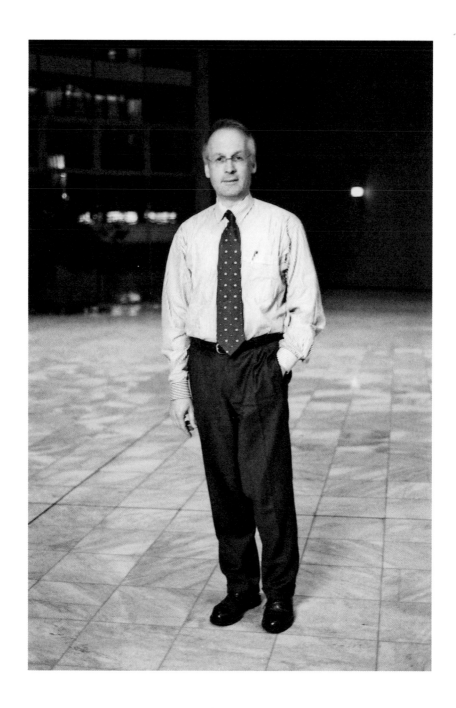

*Executive*

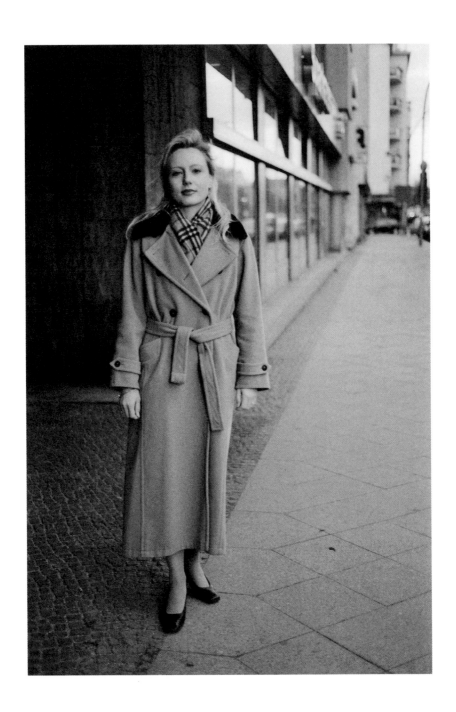

*Bank Employee*

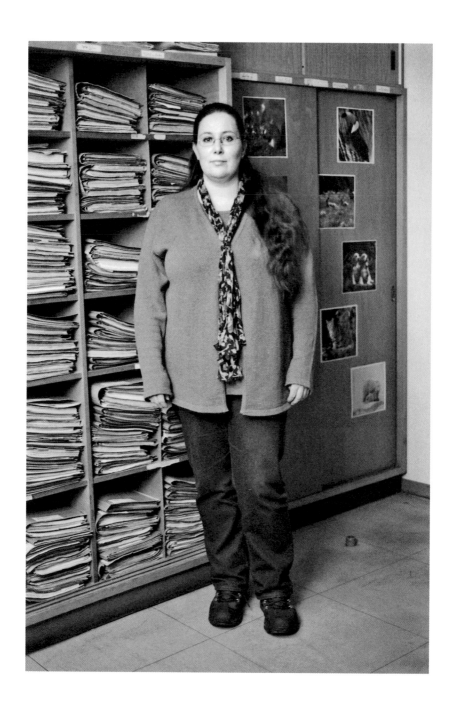

*Tax Official*

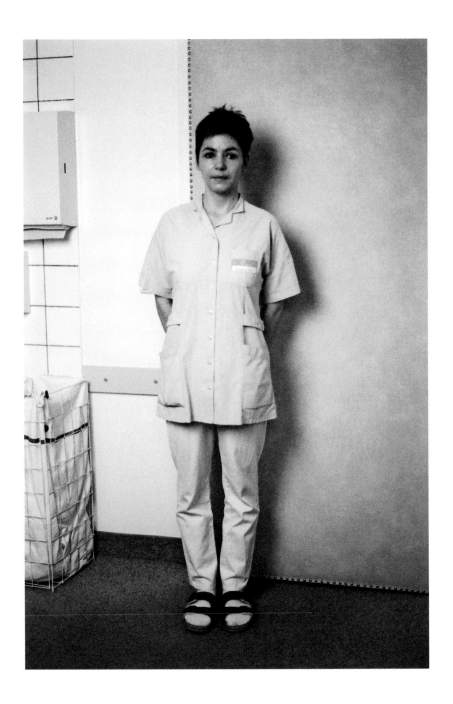

*Nurse*

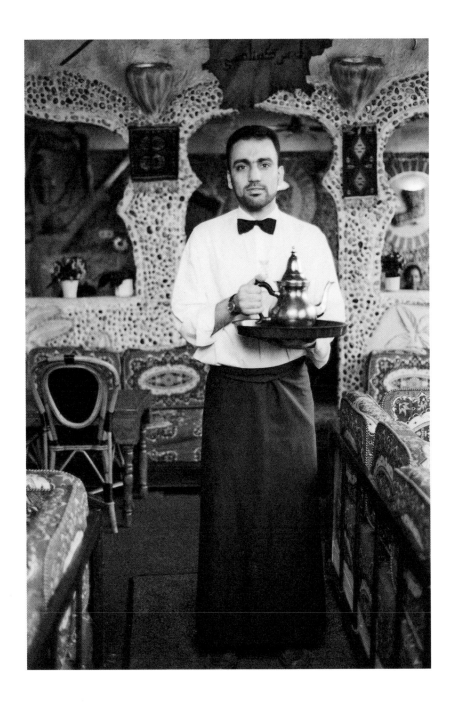

*Waiter*

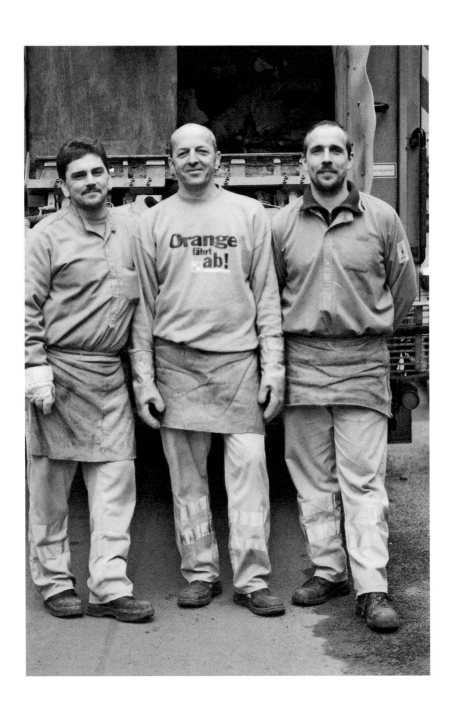

*Garbage Collectors*

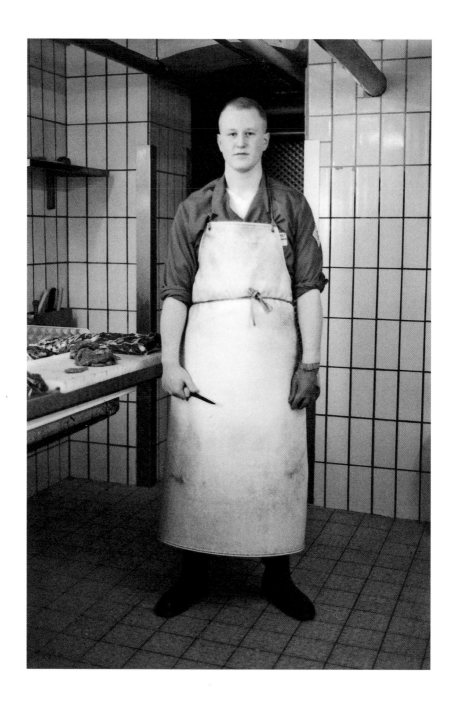

*Butcher*

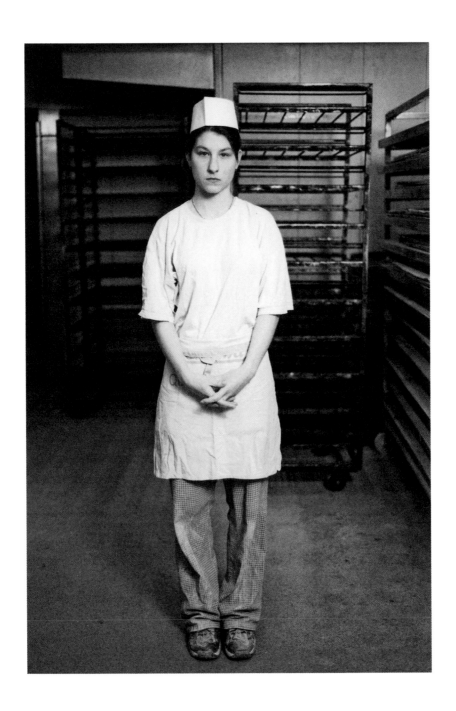

*Baker*

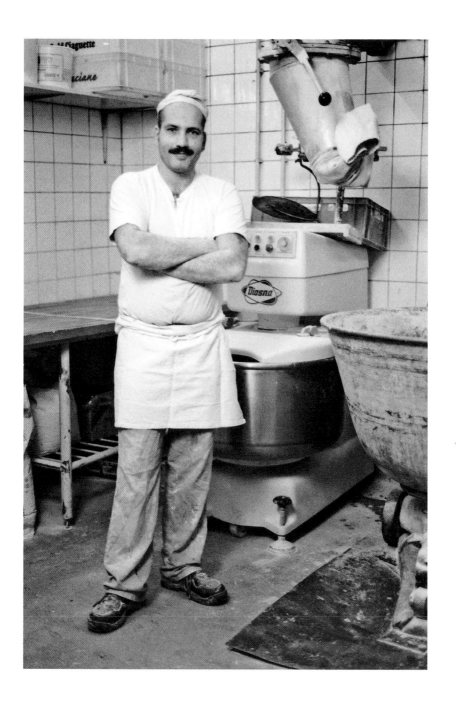

*Baker*

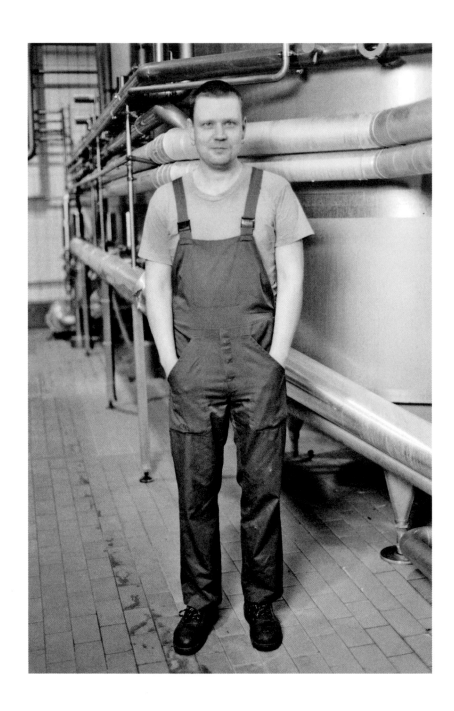

*Factory Worker*

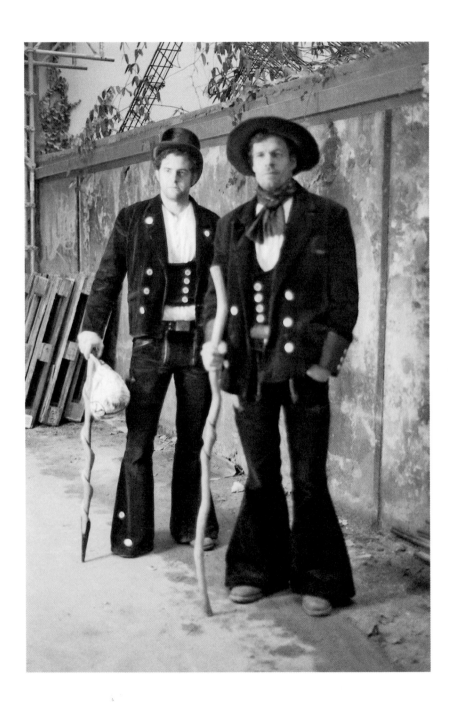

*Wayfaring Apprentices*

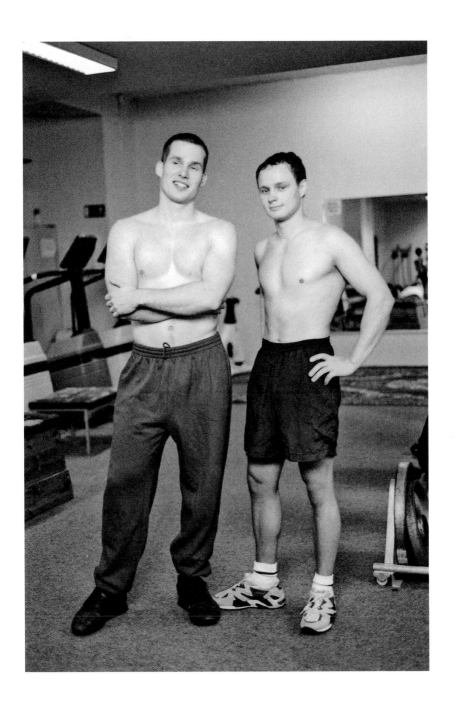

*Sports Club*

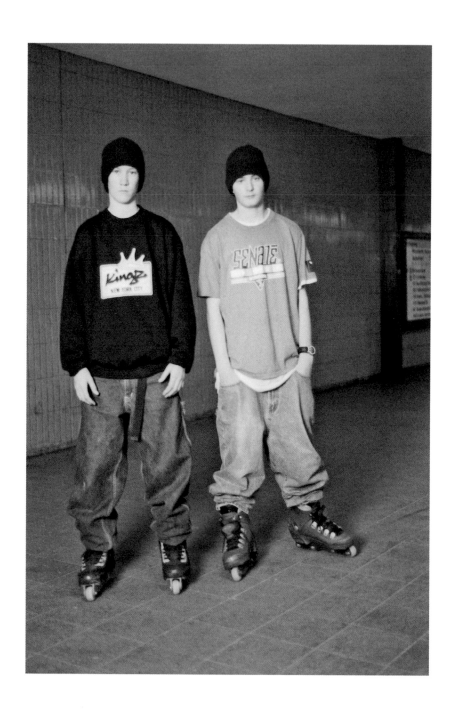

*Youth*

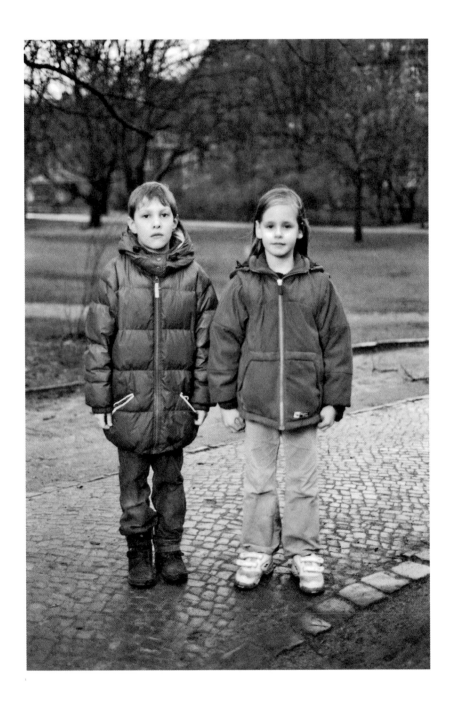

*Children*

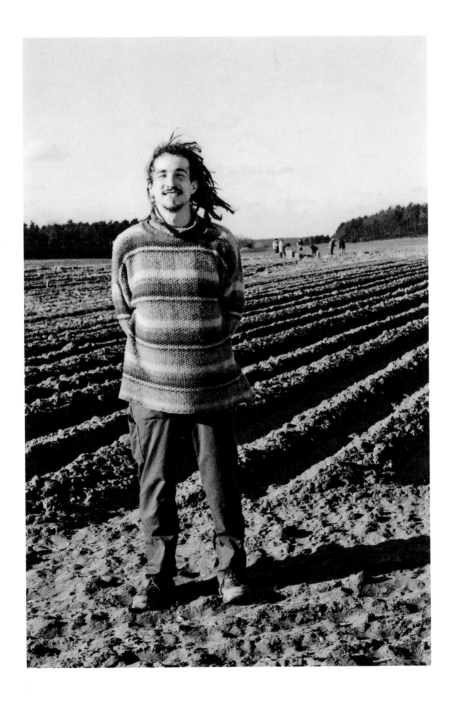

*Farmer*

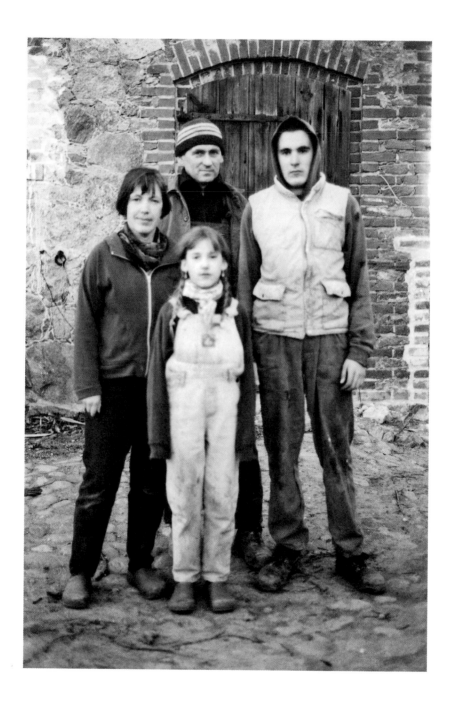

*Family*

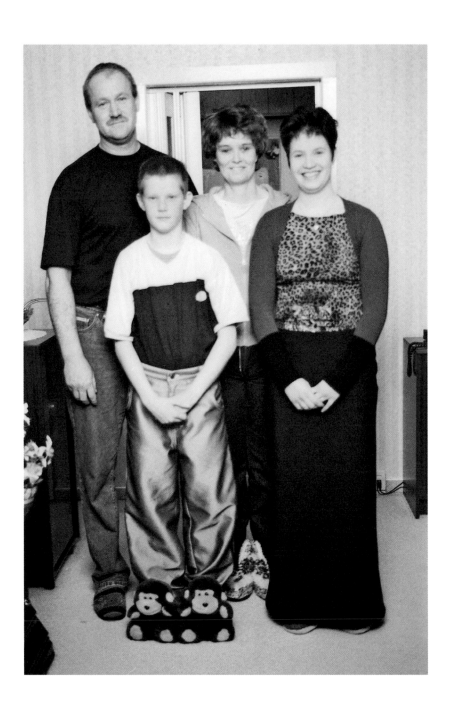

*Family*

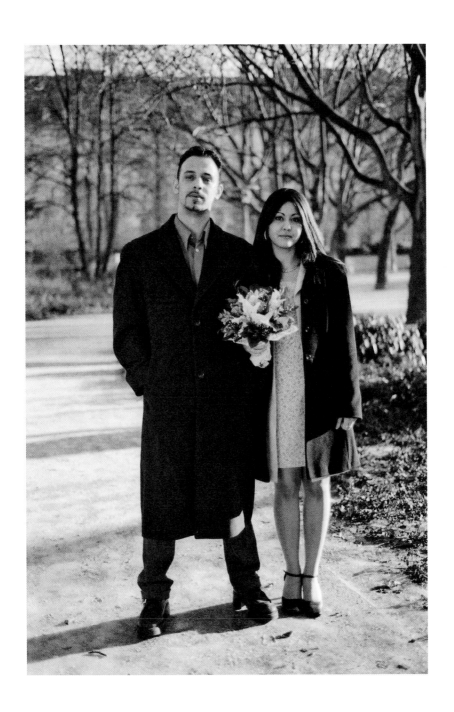

*Newly Wed*

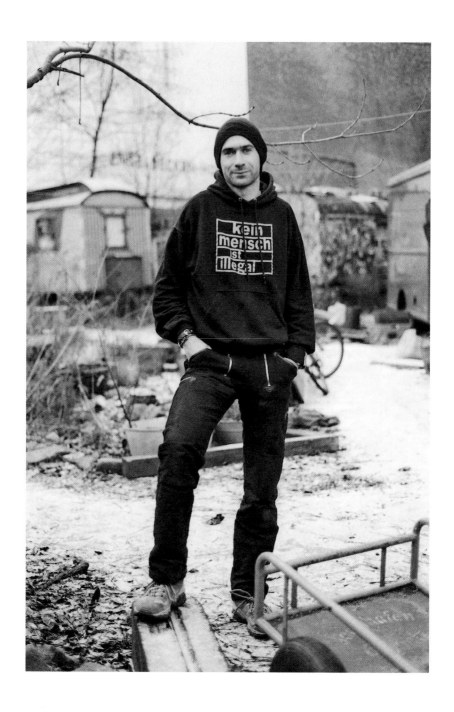

*City Nomad*

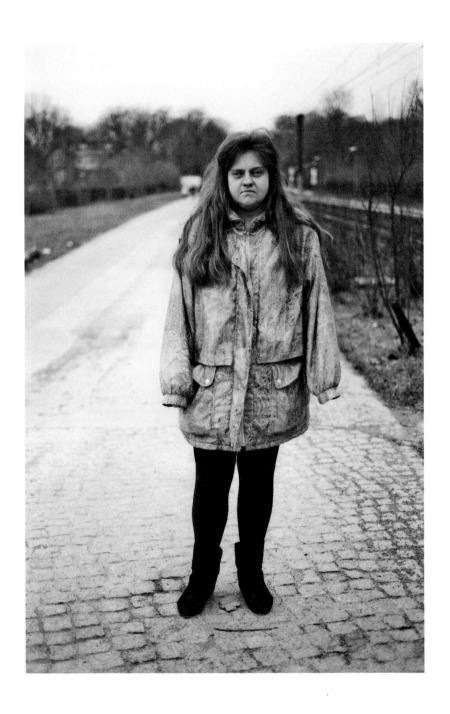

*Unemployed*

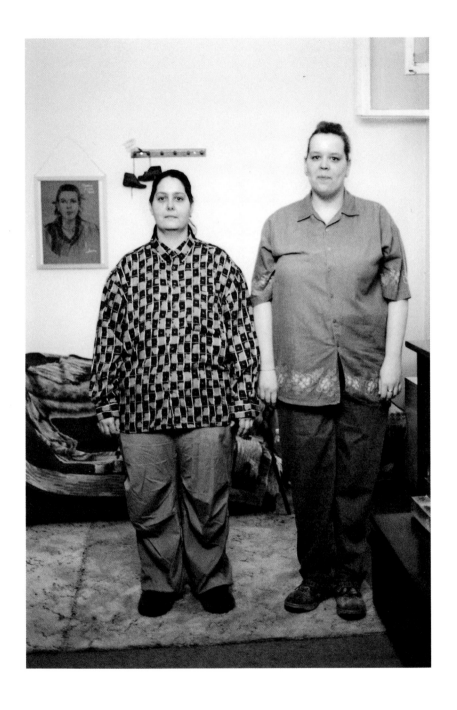

*Couple*

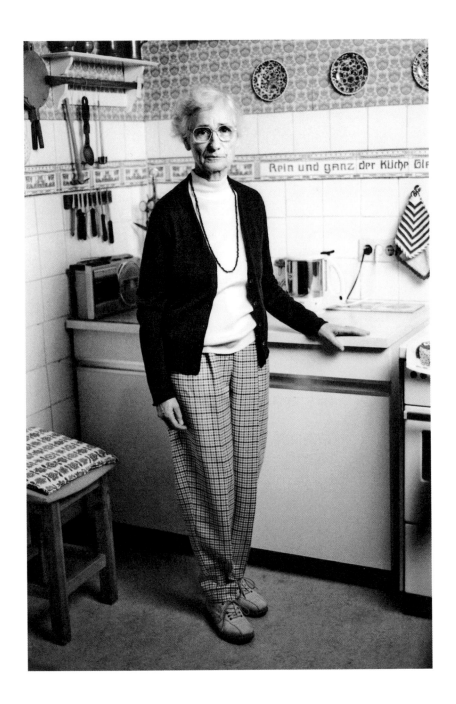

*Pensioner*

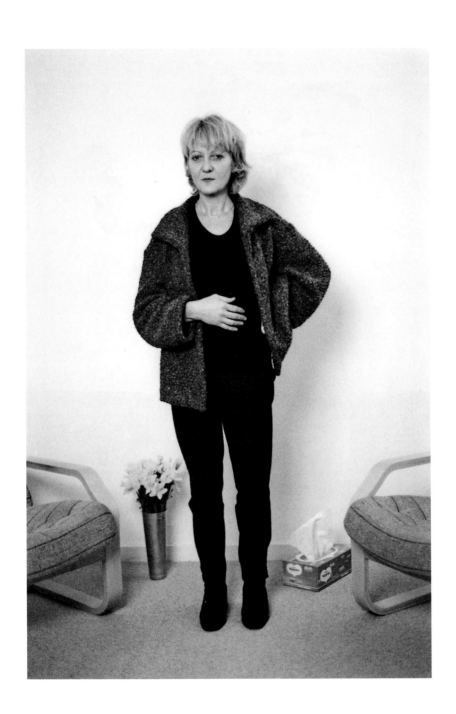

*Psychologist*

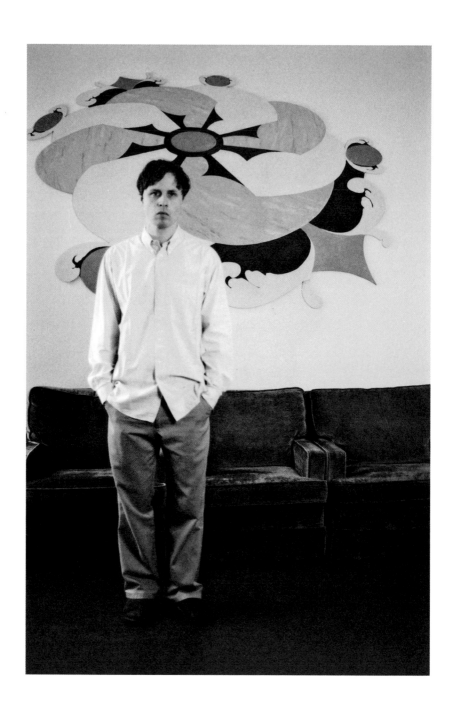

*Author*

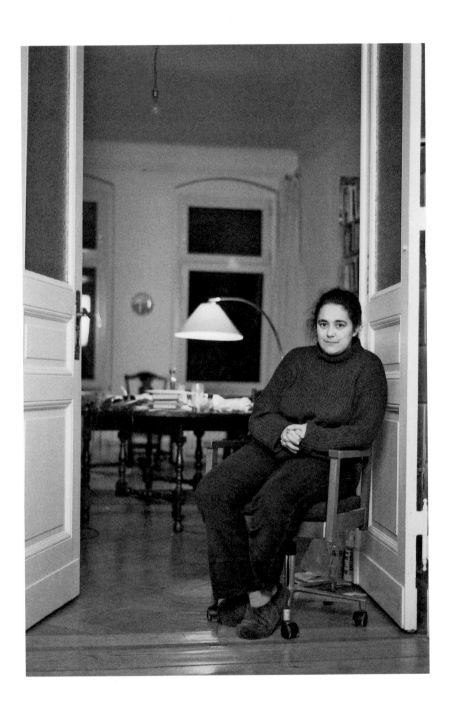

*Artist*

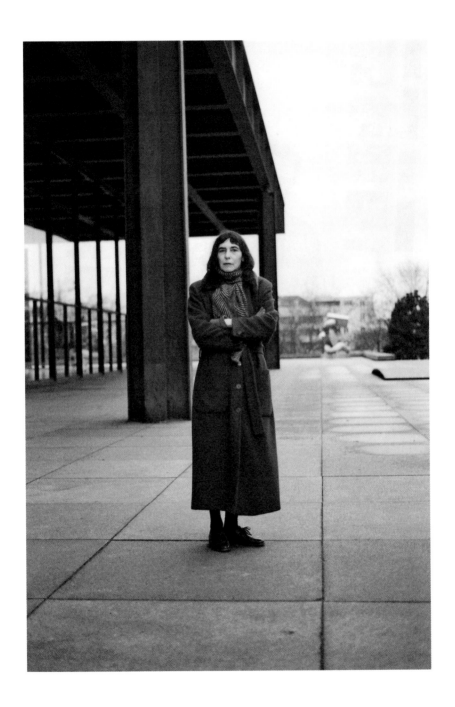

*Curator*

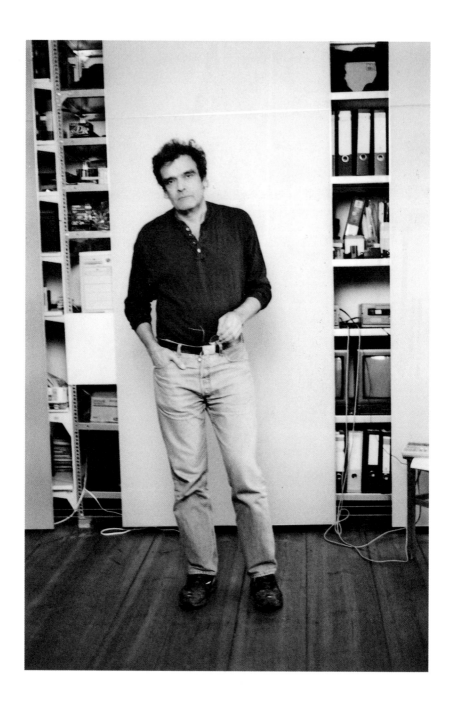

*Film-Maker*

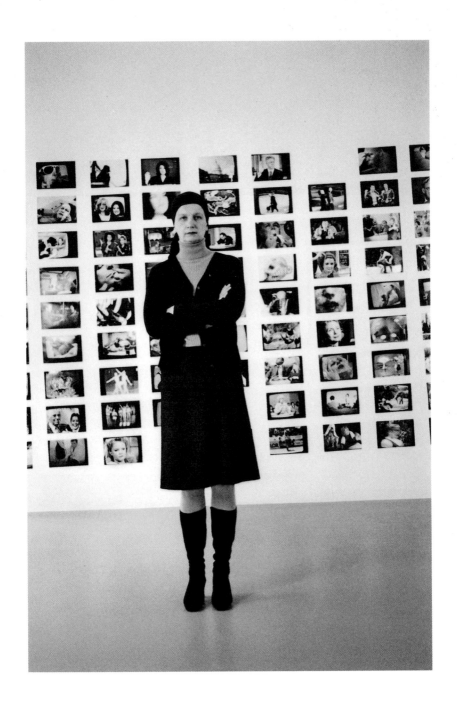

*Gallery Owner*

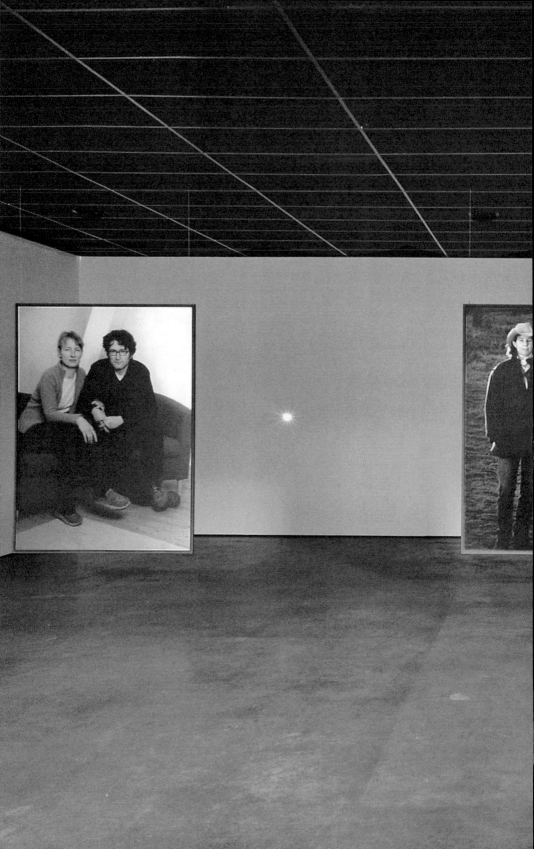

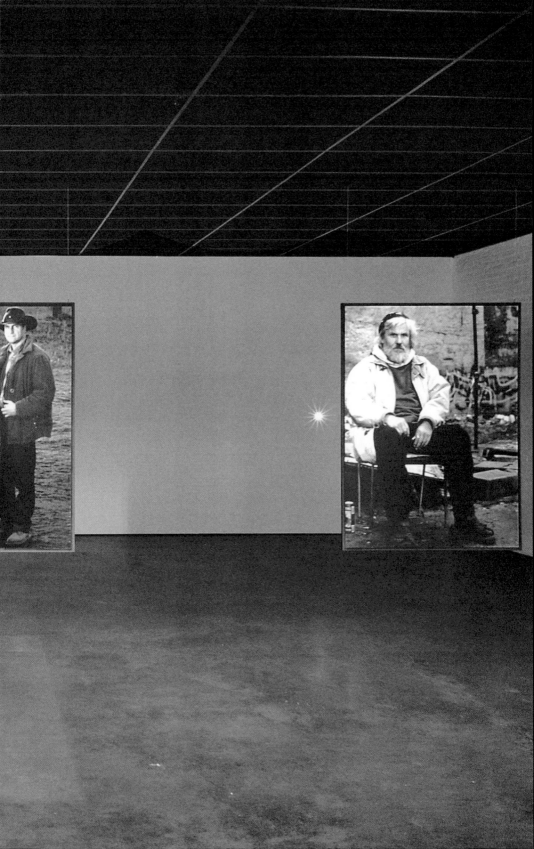

# FIONA TAN'S **COUNTENANCE**

### 1. PORTRAIT OF THE ARTIST AS....

Fiona Tan's *Countenance* (2002) begins with a self-portrait. Her face appears first, in three-quarter pose, on the smallest of the work's four screens, the one that is kept apart in the installation in a kind of annex away from the three main projections. For around ten seconds she looks at the camera confidently, blinks, and blinks again, before her face is replaced by a succession of different head shots, each lasting only a second or two. As she disappears from view, as these other faces begin to beat time, a soundtrack starts to accompany the image. Tan reads aloud a brief diary of her year in Berlin. The narration — which lasts around five minutes — serves as a factual introduction to the project. We hear that Tan was in Berlin temporarily and

that she gradually began to assemble an archive of portraits. But we do not get any precise details. We are told neither that she had come from Amsterdam, nor that she was on the DAAD programme,[1] nor that this work developed from earlier concerns, nor that she revisited the work of August Sander. We do not hear why Tan organised her archive of portraits as she did, why she made short black and white films of each subject rather than photographs, why she installed the work as she does. All these questions are ones we can explore later, before the three main screens that make up the main body of the work. Tan's narration, meanwhile, should be understood less as a factual introduction, and more as an expansion of her own self-portrait; an expansion but also a fragmentation. For many 'Fiona Tans' are presented here, many personas in one. It is a fracturing that stretches to the very heart of her project.

First, we have a portrait of the artist as a traveller. Listening to the narration we gather immediately that Tan is displaced. Having arrived in Berlin, she feels *'lighter, if also set adrift'.* Lighter, because she is released from the burdens of her everyday life, the administration and the duties and time pressures which would make a person shut themselves away from strangers in their home city.[2] 'Set adrift', Tan has much more time than usual, time to waste *'staring out the window'*, gazing at strangers. *'Do I look better at someone's face in a foreign city?'* she asks. But what would 'better' mean? As a foreigner, Tan might be more observant, she might have more time to observe, but she might also be prone to see things through her own skewed perspective, failing to understand what she sees. This much she admits, albeit obtusely. *'May 11. A map of Berlin hangs on the kitchen wall. It's an older map. The highway routes are coloured blue, and I repeatedly mistake them for waterways.'* You can hardly blame her, used, as she is, to a city of canals.

At some point in the year, the project is determined. Tan begins to collect faces. *'I gather together impressions and snapshots like an amateur biologist in the nineteenth century would catch butterflies. Type. Archetype. Stereotype.'* A self-portrait of the artist as a scientist, then. But, cutting against the picture of the artist-as-archivist is another facet of the self-portrait, the messy bohemian in the chaotic studio. Towards the end of the narration, we hear of *'hours spent sorting through my cluttered notes and papers. Hard to choose*

*what to keep and what to discard.' I'm a great one for making long lists, even*
*if they are meaningless in the end as if order outside would take care of the*
*disorder inside.'* So, organiser and clutterer, hand awkwardly in hand.

There's also a picture of the artist as fantasist. Tan recalls her childhood
facility for recognition. *'I used to think that I never forget a face'*, she says.
*Countenance*, it would seem, sprang as much from Tan's stay in Berlin, her
art historical interests, her analytical tendencies, as from her fondness for
physiognomic guessing games. In Berlin, she continues to play: *'Almost*
*automatically I try to guess someone's background and origin.'* Yet contrast-
ing the picture of the playful artist-as-imaginative-child, we have yet another
persona – that of the knowing, self-aware, self-critical DAAD scholar. This
'Fiona Tan' recognises the blind spots and the biases of the traveller. This
'Fiona Tan' is aware of the dangers of classification, telling the nineteenth
century scientist in her that *'all my attempts at systematical order must be*
*arbitrary; idiosyncratic'*. This 'Fiona Tan' reminds the child in her that guess-
ing games are always predetermined, and that there are *'details [of faces]*
*I notice'*, and others *'I let slip by'*. This 'Fiona Tan' recites the children's rhyme
*'Tinker, tailor, soldier, sailor'*, but only to suggest that as the foreign visitor and
portraitist she might be *'thief'*.

The picture of the artist that emerges from the narration is nuanced and
conflicted, and one of its effects is to undercut the authority of the image
that opened the reel. In her more conventional visual self-portrait, remem-
ber, Tan's countenance seemed confident and calm. In presenting a very dif-
ferent kind of person, her words remind us of the inadequacy of any image to
indicate the character of the sitter, that 'countenance' can mean 'mere show'.
We leave this introductory screen with some doubt about the very workings
of portraiture, but we might also be sceptical about the entire nature of Tan's
project. Its ambition is described most precisely towards the end, but hardly
with any statement of intent. Where Sander once introduced an exhibition
with the confident assurance: 'Nothing seems better suited than photography
to give an absolutely faithful historical picture of our time',[3] Tan instead
poses a question: *'Could I possibly collect, collate a time in history? Whose*
*history?'* And so we enter the rest of the installation, wondering whether she
is, as she says, *'doomed to fail'*, teeming with Tan's doubt.

## 2. CAUSES FOR CONCERN

We can ask later if and how Tan infects her archive with this doubt, but for the moment, let us pause as if between the two parts of the installation of *Countenance*, between the introductory 'self-portrait' screen and the three main ones to come. What we know so far is that Tan set out to photograph the citizens of the city she was visiting, to make an archive of the faces of Berlin, to 'collate a time in history.' We have listened to her scepticism, but just why did she deem this project to be so utterly problematic? What about it caused her concern and necessitated all the self-questioning? To answer this, we can break the project down into three parts, thinking first about its archival nature, then about Tan's engagement with the genre of portraiture, and finally, about her role as a kind of ethnographer, exploring a culture foreign to her own.

During the post-war period, and particularly in Germany, artists employed archival forms for many different reasons. When in the 1950s, Bernd and Hilla Becher began to create an archive of photographs of industrial architecture, they were not only commemorating forms on the verge of obsolescence and disappearance. They were also employing an extremely objective form of photography, countering the kind of 'subjective' humanist photography championed by Otto Steinert.[4] Gerhard Richter, meanwhile, gathered together on the panels of his monumental compendium *Atlas* thousands of photographs – some taken from found family albums, some taken himself, and many cut out of magazines or newspapers. The compendium has been called an 'anomic archive' because of the way it resists precise forms of organisation. The different kinds of photography collected in *Atlas* dramatise both the necessity of memory in an amnesiac society (for instance, Richter included photographs of concentration camps when they were hardly negotiated in German culture), and the impossibility of memory in a rapidly developing consumer culture where each new day brought new images of new products.[5] Tan's approach to the archive is certainly informed by these artistic confrontations, but it is also informed by the operations of stricter archives outside of the art context.

What, in its strictest sense, is an archive? To form an archive is to attempt to impose order on experience and on the contents of the world. The archivist

constructs categories, which, appearing objective, often only reflect their biases. Whether it is an object, a person, or a photograph, the complexity of a given piece of data is reduced by the archivist so that it can be placed into its given category. The archive flattens out peculiarity, its organisation only allowing for equivalences and basic differences to be drawn between its contents. As much as they are formed by the desire to organise information, so too in turn archives determine and limit the possibilities of knowledge. Operating in this manner, archives become fundamental to those who control and organise a society. The artist Allan Sekula, whose research has paid particular attention to the function of nineteenth century police and medical archives writes: 'Archives are not neutral; they embody the power inherent in accumulation, collection, and hoarding as well as that power inherent in the command of the lexicon and rules of a language.' 'Photographic archives' he continues, 'by their very structure maintain a hidden connection between knowledge and power. Any discourse that appeals without scepticism to archival standards of truth might well be viewed with suspicion.'[6]

It is for these reasons that Tan reminded herself in forming *Countenance* that '*all my attempts at systematical order must be arbitrary, idiosyncratic*'. But she would have known the danger of archives, and their lure, from her earlier work. The footage she used for *Facing Forward* (1999), **[p. 81]** for instance, was sourced at the Filmmuseum archives in Amsterdam, and included films from the early twentieth century made by Europeans in various parts of Africa, Asia, and Australasia. Whereas, one imagines, the Filmmuseum archive is strictly organised by country, or date, Tan deployed various fragments according to different principles. At the very beginning, for instance, Tan juxtaposed three fragments of footage whose similarity for her derived not from shared location, but from the fact that in each of them, the cameramen had used a panning shot. The viewer of Tan's work becomes as much aware of what Europeans saw in these places as of how their recording equipment and filming techniques determined particular ways of seeing.[7] Where some clips in Tan's film occur only once, other fragments are repeated again and again, exchanging the economy of the archive for a different kind of rhythm. *Facing Forward* ends with a close-up of two girls, laughing and playful. As Lynne Cooke, who has attended to the way the work explores the different visual regimes of the ethnographer and the traveller, observes:

'these young women reconfirm the inherent ambiguity, the unknowability of the Other and, at the same time, given their irreducibly affecting presence, affirm their singularity and individuality as subjects.'[8] Confronting the archive with all the scepticism of one aware of the intrusive and exploitative activities of the original filmmakers, Tan rescues its material, drawing imaged subjects closer to their viewers.

With its images of two faces, the final shot of *Facing Forward* brings us to the question of portraiture, the second main device of *Countenance*. As Benjamin Buchloh has argued, the very legitimacy and possibility of portraiture is questionable now, yet time and time again, artists manifest a 'desire to confide [themselves] in the genre.'[9] If each renewal of confidence takes place in different conditions, the reasons for doubts about its legitimacy are not difficult to fathom. Portraiture, at least in its traditional manifestation, shored up a notion of the individual aristocratic or bourgeois subject, self-knowing and self-sufficient.[10] The late nineteenth century brought many changes in the way subjectivity was understood: Marxism insisted on a conception of the subject inseparable from its class and economic determinants, psychoanalysis posited a model of the subject as internally split, driven by unconscious fantasies and desires. With its faith in mimetic resemblance alone as a guarantor of the subject's representation, with its insistence on the very idea of the individual, how could portraiture survive with any authenticity into the twentieth century?

One way would be for artists to insist on the social and economic positioning of the portrayed subject, and to submit portraiture to the logic of the archive, exchanging the single image for a compendium. This brings us to August Sander, the bedrock of *Countenance*. Sander's *Citizens of the Twentieth Century* was by far the most impressive and ambitious photographic portraiture project of its time. Begun in 1910, yet incomplete at the time of Sander's death in 1964, the project had been distilled in 1929 in the publication *Antlitz der Zeit* (differently translated as *The Physiognomy of Present Time*, or *Faces of Our Time*). Believing in photography as a 'universal language', in physiognomy as a means to understand character,[11] and in the possibility that one portrayed subject could stand for a whole type (be it a profession, or social group), Sander felt confident that his project would

provide an accurate document of German society and would assist others in the study of physiognomy.[12] The completed work would be divided into forty-five portfolios, each containing twelve photographs, spread across seven sections: Farmers, Workers, Women, Occupations, Artists, The Big City, and The Last People. Society was represented in a cycle, starting with farmers, 'ascending' through workers to skilled professions, to artists, and then 'down', to vagrants, prisoners, the oppressed, and the disabled. The organisation of the work would reflect Sander's 'assumption that history follows a cyclical pattern, that society is made up of a guild hierarchy, and that the world of work and the private world are distinct.'[13]

Introduced at the time of its publication by Alfred Döblin's assurance that with their 'scientific viewpoint', the photographs 'provide superb material for the cultural, class, and economic history of the last thirty years',[14] *Antlitz der Zeit* was embraced by Walter Benjamin. Sander's was 'a very impartial, indeed bold sort of observation, but delicate too.' 'Whether one is left or right,' he wrote, 'one will have to get used to being looked at in terms of one's provenance. And one will have to look at others the same way. Sander's work is more than a picture book. It is a training manual.'[15] Benjamin's endorsement points to the gulf between Sander's physiognomy and the racial theory fundamental to Nazism.[16] Despite Benjamin's appraisal, and without for one moment questioning the consistently impressive compositional beauty of Sander's images, subsequent critics have pointed to the flaws and dangers in Sander's project. Roland Barthes asked: 'Is not the very capacity to perceive the political or moral meaning of a face a class deviation?' Only those in power, he indicated, could read from the training manual – 'No critique except among those who are already capable of criticism.'[17] Buchloh, meanwhile, has written that Sander's 'is a model of portraiture that, while serial in its organisation, nevertheless argues the case of a social determinism – that of a preestablished social 'ontology' so to speak – where each individual finds his or her natural place and position in a hierarchically and cyclically structured preestablished order.' Sander's thinking was even outdated in the 1920s since 'a model of subjectivity based on the definition of professional identity had already become obsolete by that time – derived as it was in Sander's case from a nostalgic longing for the social order of the medieval guilds.'[18] Ulrich Keller affirms that 'an arrangement according to

social classes would have been more appropriate than guild rubrication.'[19] Allan Sekula points to a different problem. Sander's project fails to show the mobility and the fluidity of Weimer society. 'Sander's compendium of portraits [...] possess a haunting – and ideologically limiting – synchronicity for the contemporary viewer. One witnesses a kind of false stasis, the appearance of a tense structural equilibrium of social forces. Today, Sander's project suggests a neatly arranged chessboard that was about to be dashed to the floor by brown-shirted thugs. Despite Sander's and Döblin's claims to the contrary, this project was not then and is not now an adequate reading of German social history.'[20]

In deciding to engage Sander's *Citizens of the Twentieth Century* so directly, Fiona Tan would have considered the various critiques of his project. How she attempted to address them we shall see, but for now, we can be sure that these criticisms further account for the self-questioning tone pulsing through the narration in the introductory film. But we need also to think about the more recent history of portraiture, for this would only contribute to Tan's doubt. An entire generation of Pop and Conceptual artists, from Warhol and Lichtenstein to Boltanksi and Kawara overturned the very basis of the genre by wresting portraiture from mimetic resemblance.[21] But it is Douglas Huebler's *Variable Piece no. 70* (begun in 1971) that most obviously took up, and deflated, Sander's ambition. The work was announced with the following declaration: 'Throughout the remainder of the artist's life he will photographically document, to the extent of his capacity, the existence of everyone alive in order to produce the most authentic and inclusive

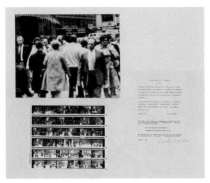

Douglas Huebler *Variable piece no. 70*, 1971

representation of the human species that may be assembled in that manner.' This sentence was printed on every individual work in the series, which would normally include a contact sheet usually of casually taken street photographs, a blown-up photograph from the sheet, and a typewritten piece of paper with a 'declaration' such as: 'Represented above is at least one person who would rather be almost anyone else' or other pat phrases: 'One person who would do anything for a laugh'; 'One person who blames every-one but himself' and so on.[22] Rather than declaring the imaged subject to be representative of a profession, or a social group, Huebler's captions ridiculed the very act of categorisation, and threw the responsibility for labelling back onto the viewer. As the caption did not specify the person in the photograph to which it refers, it was up to the viewer to decide whether to connect the text and image at all. Even if they did, the caption was just a cliché.

Leaving the crisis of portraiture, we come to the third aspect of Tan's project which is its ethnographic character. Where Sander was a citizen of the country whose populace he imaged, Tan came from abroad to Berlin on a one-year programme. Just as a generation of artists posed questions about the traditional functions of portraiture, so too ethnographers over the past half-century have scrutinised the operations of their practice. Many of the critical questions they have raised might apply to her project – what propels the ethnographer to form an account of their subject? To what extent is their observation informed by their own background? What projections do they make? How objective can they be, and do they represent her desire and sub-jectivity in the work? Of course these are questions utterly familiar to Tan, given her negotiation of ethnographic film. Part of her ambition in previous work has been to suggest the determining functions of viewpoints and appa-ratus for early ethnographers. In *Facing Forward* the images of non-western

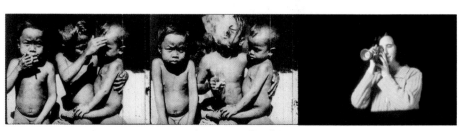

*Smoke Screen*, 1997, video stills

subjects are inter-cut with a slice of film showing the cameraman. In *Smoke Screen* (1997), this strategy is revisited. Tan cuts found footage of young boys smoking with passages showing her, in a darkened studio, holding up a toy camera. If in these works Tan reminded the viewer of the position of the ethnographic filmmaker, perhaps one of the challenges for *Countenance* was to continue this project, declaring, rather than concealing, her position, and her desire, as the ethnographer in Berlin. In any case, it is the critique of ethnography that accounts for the third of the causes for concern.

## 3. TAN'S ARCHIVE

In 'The Artist as Ethnographer', an essay which explores the relationship of recent art and ethnography, Hal Foster articulates a double-problem. The artist might pursue a project with all the biases and naivety of an unself-critical ethnographer, but they might also develop work in which 'the deconstructive-ethnographic approach can become a gambit', work so very self-questioning that it ends up 'hermetic and narcissistic.' 'Criticality' becomes 'contemptuous', the humility of self-scrutiny flips over into the hubris of self-congratulation, and far from negating their authority, the artist once again enforces their superiority over the objects of their survey.[23] This articulation, I think, helps to describe one of the key dangers that might have faced Tan as she set about making *Countenance*. Yes, there were problems in building an archive, in confiding in portraiture, and in mapping a culture foreign to her own, but had her work been merely a deconstruction of these three methods, had the self-questioning of the first reel been amplified, she would have risked the hermeticism that Foster describes. To see how she avoided this, let us return to the scene of the installation, and proceed into the main room, where we find before us three screens, each hung vertically, each containing a succession of portrait films. All in all, there is around an hour and a half of material, some two hundred and twenty faces. As the viewer sits down to watch, it is not long before they sense that self-scrutiny of the work is matched by its generosity.

Tan's archive is organised in three main sections. The screen to the furthest left collects 'SOCIAL CONSTELLATIONS'. After this main heading on a title frame, the subtitle 'Single' appears followed by a succession of fifteen to

twenty second portrait films of single people. Then we have eleven further subcategories: 'Newly weds', 'Couples', 'Mother and child', 'Father and child', 'Family', 'Child', 'Youth', 'Flat mates', 'City Nomad', 'Sports club', and finally 'Geriatric home residents'. Though the first category had five examples of single people, the number of films in each following category differs. For instance, there are nine 'couples', but only three 'fathers and child'.

The central screen commences with the announcement of a new main category, 'WORKING PEOPLE'. We begin, following Sander, with the sub-category 'Farmers' before moving to 'Worker', which subdivides in turn into six sub-sub-categories: 'Factory worker', 'Unskilled worker', 'Building labourer', 'Painter', 'Bricklayer', and 'Working Prisoner'. The next main subsection of 'Working People' is 'Craftsmen' which includes 'Butcher', 'Baker', 'Carpenter', 'Candle maker', 'Futon maker'. And so on. Other main subsections are 'Working People', 'Technicians', 'Civil Servants', and 'Employees', which are, in turn, each subdivided. Interestingly, the three main divisions of Tan's archive fail to correspond to the three main screens of her installation: 'Working People' spills over onto the third screen where the next subcategories are 'Self-employed', 'Medical Professional', and 'Freelancer'. Around half-way through this third reel, a final main category commences, 'MISCELLANEOUS', subdivided into 'Student', 'Pensioner', 'Politician', 'Curator', 'Unemployed', 'Homeless', 'Beggar', 'Drug addict', 'Filmmaker', 'Artist', and, finally, 'Author'. As with the first reel, the number of examples in each subsection differs. Quite clearly, Tan did not seek the same number of

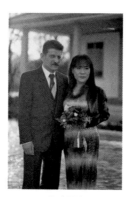

*Newly Wed*

representative examples of each sub-category. The number of portraits in any given section instead reflects the contingencies of her interests and her contacts in Berlin – there are far more 'artists' than 'authors', for instance.

What, then, do these various portraits tell us about 'a time in history', to recall the phrase from the opening screen's narration? Part of what we learn comes from the comparison with Sander's archive. Tan's first category, 'Social Constellations', includes many of the groupings that were found in 'Women' (the third main section of Citizens) but witnesses various changes in sexual politics since the 1920s. Sander's only 'father and child' photograph imaged a widower, whereas Tan represents fathers in unexceptional circumstances who might be primary carers. Sander's couples are all heterosexual, whereas Tan's equivalent grouping features a lesbian and a gay couple [p. 47], an inclusion which we might remark in passing also witnesses a gulf between hers and Thomas Struth's portraiture.[24] Notable also in the 'Newly wed' section is the pairing of a white middle age man (grinning) and his younger, Thai wife – a coupling that might suggest a new racial tolerance but that might also point to the way exploitative economic relationships between Europe and South East Asia lead to exploitative social ones.[25] The archive separates the categories of 'social constellations' from 'working people', but the inclusion of this example deliberately indicates the inadequacy of this division – working conditions create social constellations, and visa versa. And just how different is a 'Thai bride' (if she is one) from a 'Prostitute', who is firmly placed in the 'Self-Employed' subsection of 'Working People'? [p. 9] This portrait is also remarkable when thinking back to Sander. Not only were prostitutes unrepresented in his rather sanitised account of Weimar Germany – Tan's prostitute occupies an indeterminate gender position medically impossible in the 1920s ('she' seems to be a post-operative transsexual).

Concentrating on 'Working People', once again there is much we can learn about the moment in history. Farming, for instance, can now be a life-style choice. One of the most beautiful images is of a young dread-locked man in a thick-knit jumper standing in a field. [p. 39] Whereas the suits of Sander's farmers might suggest the ambition to rise 'above' their station,[26][p. 72] this farmer might indicate a reverse tendency. His appearance (and I am of

course projecting here) suggests the uniform of 'green activists' who start life in cities and consciously orient themselves towards the country. In the city, conditions of labour have changed too, as have the gender of workers. Though, in 'Social Constellations', the number of child-caring mothers out-balanced fathers, indicating the continuation of unequal domestic roles, and though all four of Tan's 'executives' are men, women now occupy a far vaster range of professions than Sander's secretaries and nurses.[27] The second image in the 'Working People' category is a female factory worker, her gloved hand gripping a machine. But machines have also replaced hand-work. One of the portraits with the most dramatically contrasting counterpart in Sander is the baker. Sander's holds a medium-sized mixing bowl with one hand, and stirs dough with a large spoon grasped in the other; the arms of Tan's moustachioed baker are firmly folded, while a large mechanical mixing machine stirs a mammoth vat to his left. [p. 31] Meanwhile, in an increasingly bureaucratised and mediated society, the largest category of 'Working People' is, unsurprisingly, 'Civil Servants', and the number of 'Media Specialists' matches 'Factory workers'.

In the opening narration, Tan mentions walking in the park and hearing *'East German accents'*. These are not audible in *Countenance* since none of her subjects speak, but we might well ask how her archive represents the integration, or non-integration, of what, just over ten years previously, had been two split communities. In the re-united Berlin, whose new buildings tower over the shoulders of one of Tan's freelance architects, former national divisions are still witnessed by economic and social distinctions.

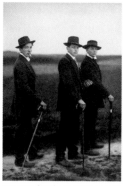 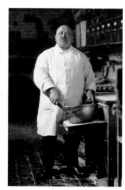

August Sander, *Three Farmers*, ca. 1914    August Sander, *Pastry Cook*, ca. 1928

Would a resident of the city be equipped to detect 'East German appearances' in *Countenance* and to know, for instance, whether the archive represents a greater number of Easterners in less-well paid professions? Would they be able to judge whether the archive's representation of economic divisions matches the realities of Berlin circa 2001? While Tan sparks off this enquiry through her reference to 'accents', and in so doing breaks taboos about the representation of the city,[28] one of the deliberate strategies of her project is to frustrate it. Portraits, after all, do not deliver the required information, and certainly watching the work outside of Germany, it is hard to fathom which people were born where. What can be noted, however, is the position of non-white residents of the city. There are few darker faces in academia, finance, or the arts, but the food industry includes an Indian cook, a Turkish waiter and a kebab shop carver. Standing against elaborately decorated cushions and a mosaic wall, the waiter carries an 'oriental' teapot, [p. 25] tempting customers to forget the Starbucks in Istanbul.[29] Whether or not East Berliners are seen disproportionately to occupy labouring jobs, it seems that the condition of employment for recent immigrants is about caricaturing and selling their cultural difference.

Each new section of the archive is introduced with a screen where a title appears in German and English. The German is typed, in a modern, sans-serif font; the English hand written, and on one title, scratched out and re-written. These titles exemplify the rather schizophrenic character of the archive, at times apparently objective (the subdivisions of the 'Medical Profession', for instance), and at times very quirky, especially in the 'Miscellaneous' section towards the end of the third reel. Why are 'curators' placed between 'politicians' and the 'unemployed', for instance? (You sense a joke between Tan and her sponsors, as the first face in the category is that of Friedrich Meschede who runs the DAAD programme.) Why are 'artists'[p. 53] last, in the place occupied in *Citizens* by victims, the persecuted, and the blind?[30] Such questions prompt other more general ones, and ones about the similarities rather than the differences between Tan's and Sander's archives. No matter how quirky some sections are, for the most part Tan keeps with pretty rigid categories. It is certainly not the case that the portrayed subjects are divided by characteristics such as 'contentment', or 'sociability'. What does it mean now to persist with Sander's main divisions?

Is subjectivity still mainly determined by work and familial groupings? Do the categories fail to do justice to the individuality of the subjects? If they don't, perhaps the medium Tan employs has this role instead.

## 4. MOVING PORTRAITS

The most obvious difference between Tan's and Sander's projects is of course that Tan's is not made up of photographs but of short films. These were shot on 16mm, which meant that before filming, considerable time had been spent setting up lighting, selecting lenses, and adjusting focus. Tan would get to know the subject during this setting-up period, or rather, resume their acquaintance. For some weeks before the shoot, each subject had been contacted and introduced to the project, being told both how they would be categorised in the final work, and about the precedent of August Sander. On the shoot, each subject was filmed twice, each time for around a minute.

In selecting the medium of film, Tan was extending what can increasingly be seen as a sub-genre of portraiture, whose origins lie most obviously in Andy Warhol's *Screen Tests* (1964-66). These were close-up head-shot films of visitors to the Factory, often dramatically lit, each filmed for the length of a reel (around 4 minutes), but projected slightly slower than they were recorded. In the last few years, the genre of the moving-image portrait has swollen to accommodate James Coleman's *Untitled: Philippe VACHER* (1990), Gillian Wearing's *Sixty Minutes Silence* (1996), Rineke Dijkstra's *Annemiek (I wanna be with you)* (1997), Thomas Struth's one hour long video portraits (1996-97), Catherine Yass's *Town* series (2000), Tacita Dean's *Merz* (2002), and Sam Taylor-Wood's film of David Beckham (2004), to name some of the most disparate examples. What is the effect of the moving image on portraiture? When he had his photograph taken, Roland Barthes commented that 'I am neither subject nor object but a subject who feels he is becoming an object.'[31] One facility of the moving-image (at least where the subject is awake) is to challenge what might be the objectifying power of photography. No longer frozen in time, the subject is living and breathing. Tan had explored the dynamic of the still and moving image before she came to make *Countenance* in the work *Tuareg* (1999), made using a fragment of archival footage of North African children lining up to have a photograph taken. The

film is successively run and frozen, re-played and re-frozen. In its still state, the image asks to be read as an objectification of the colonized 'other', but as it runs, the figures break out into play, squabbling as would naughty children anywhere, so the ocean between twenty-first century viewer and these subjects evaporates.

One way to explain the use of film in *Countenance*, then, would be that it acts against the objectifying force of photography and allows the subjects to assert their individuality in the face of the archive's cold classification. However, this argument relies on two somewhat simplistic and misguided premises: that a subject of a still portrait is simply objectified, and that a subject of a moving-image portrait is necessarily 'liberated'. Things, of course, are more complicated. To start with the first half of this assumption, one of the ways in which subjects of static portraits assert their authority is the pose. Graham Clarke has shown how this works throughout Sander's project in order to conclude that 'While [Sander] seeks 'types', he celebrates individuals.'[32] Throughout *Countenance* we can see subjects who have very deliberately chosen poses, aiming to present themselves as individuals.[33] One example would be the suite of four 'Executives', all of whom know how to present an imposing image of themselves in their office.[p. 20] Another would be the single shot of three 'Garbage Collectors', [p. 27] who impressively recast one of the earliest and most famous of Sander's photographs – the *Young Farmers* (1914). [p. 39]

But as much as a pose can indicate the subject's authority, so too it can reveal the anxiety of self-representation. The pose is less a choice made by the subject, but a choice made for them. The first reel of *Countenance* includes a portrait of teenage 'skater boys' who with their tight grouping, toughened postures, and stern expressions so obviously try to inhabit the image of the hip-hop group, an image they see everyday on MTV. [p. 36] The veil of toughness barely hides their fragility. If some poses, even when still, advertise the anxieties of the subjects, the film medium has the effect of emphasising such anxieties, dramatising the difficulty of self-repre-sentation (rather than bringing frozen objectified subjects to life).[34] Throughout the archive, we watch people failing to keep still. Sometimes this can be funny, particularly when the subject breaks out into infec-

tious giggles. But more frequently, we see sidewards glances, twitching hands, fidgeting fingers, more unnerving signs of failure.

But to what effect is all this movement? Let us suppose we watch the succession of 'civil servants' and note how some manage to keep still, whilst others are twitchy. Perhaps we can forget their archival classifications as 'judge', or 'social worker', and class them instead as 'confident' or 'nervous'. We are back to the argument that the film medium acts to disrupt the archival categories and to emphasise the character of the subjects. However, this does not seem entirely convincing. I want to suggest instead that by underscoring all the twitches, the film medium is pointing to something more general than any particular person's nervousness – pointing to the way subjectivity itself is technologically determined. What I mean by this is that new technologies produce new forms of subjectivity. Think, for instance, about the anxiety that is produced by email and 24-hour accessibility as opposed to regular mail. How could a work of art represent the way shifts of technology produce shifts in subjectivity? Only by superimposing two different technologies to examine their misfit. In *Countenance*, Tan makes film inhabit photography's old clothes and the confusion caused shows up in the fidgets. Subjects pose as if for a photograph. They pose only for a short duration (Tan's films are far shorter than the other examples of moving portraits mentioned above); they pose fully aware of the photographic precedent of Tan's project, but they are tripped up by film, a medium for which they are ill prepared. All this is to say that by bringing the film medium into what need only be a photographic project, Tan expands the realm of its account of subjectivity. Subjectivity is not only represented in its social and professional determinants, but technological ones too.

So far I have only been thinking about the stillness or movement of the subject. However, as soon as you begin to watch *Countenance*, you are struck by the movement on the periphery of the image, and by the sounds that were recorded all around the portrait scene. Once again, the impact of this movement and sound is complicated. This movement can contextualise the image and make the work's representation of German life seem much more vivid. Friends are harvesting the field behind the dread-locked 'farmer'; the class chatters in front of the 'teacher', techno pumps in the 'musician's' studio.

More often than not, though, there is an opposite effect. Appearing utterly extraneous to the requirements of the archive and of the portrait, the flashing lights and sounds of the city only serve to underline the absolute obsolescence of the entire project, and to undermine it. Listen to the noise, watch the people passing by, and more and more the project seems out-of-place, out-of-time, increasingly ridiculous. It is as if the subjects are being snatched away from their more important pursuits to take part in an anti-quated ritual. The black and white stock, and the grain of the film drive this point home.[35]

I have been hoping to show that sound and movement always have a double-effect in relation to Tan's archive of portraits. The medium can help to expand its investigation of subjectivity, to dynamise its presentation of Berlin life; in short, to justify the project. If we recall the criticism that Sander failed to represent the mobility of Weimar Germany, we could say that Tan answers this criticism in relation to her representation of millennial Berlin, and as much through what she presents (new buildings, professions, sexualities, racial groups, etc.) as how she presents it. At the same time, sound and movement acknowledge the anticipated critiques of the enter-prise and infect the archive with the doubt that was present at its inception; a doubt that was sown in the mind of the viewer as they encountered the self-portrait narration in the first room of the installation. The form of the installation in the main room also has a double-effect. Facing a bank of three projections, the viewer seems to be in a position of control, as if masters of the archive before them. (In her next work, *Correction* (2004), which gathers video-portraits of prisoners and guards in United States prisons, Tan deploys a very different installation form, surrounding the viewer with screens so that they could not see them all at once.) But the brevity of each film denies the possibility of extended scrutiny, and the ever-varying combination of figures across the three screens prevents the viewer from determining always how the three have been categorised, especially as the main grouping 'Working People' overlaps from the central to the right-hand screen. The only way of determining the structure of the archive would be to sit in front of each screen for its full duration (which is pretty unlikely in a context such as *Documenta* where the work was first shown), and even then, the move-ments on the adjacent screens would catch the eye and divert attention.

Whereas Sander's 'viewer' can turn the pages of his books at their will, here the images on the screens unfold without the viewer's control, so the possibility of understanding the archive's organisation diminishes. **[pp. 58-59]**

## 5. COUNTENANCING

August Sander had a great faith in countenances, insisting that 'we can read in [a] face whether [someone] is happy or troubled, for life leaves its trail there unavoidably.'[36] This essay started with Fiona Tan's self-portrait, and with the way her narration, at the very beginning of her work, troubled Sander's faith. In this sense, 'countenance' means 'facial expression', 'appearance', or 'bearing', but the word can also be a verb. To 'countenance' something is to accept or tolerate it. It is not quite the same as to confide in something. Countenancing is a form of acceptance that retains a degree of reserve, not begrudging, but wary. It is this notion of countenancing that I want to end with, for it is the most compelling aspect of Tan's practice.

In *Countenance*, as we have seen, Tan was working with three extremely problematic methods. Neither naively disavowing the difficulties, nor making them the absolute focus of the work, Tan acknowledged the problems, expressing and emphasising them in so many ways, but in the end, she countenanced the archive, the ethnographic project, and the genre of portraiture. Before watching the work it might have seemed unlikely if not impossible that a critical artist would work with such methods; that someone could travel from one country to another to build an archive of portraits. But Tan retrieved what had seemed bankrupt tools to make a project whose self-awareness matches its documentary ambition.

Countenancing is a consistent operation in Tan's work. As we have seen in passing, in early works Tan has used material from first contact ethnographic films and has found a way to redeem this footage despite its often objectifying or patronising character. Just before she lived in Berlin, she travelled to Japan to make *Saint Sebastian* (2001), a film of an archery ceremony involving young Japanese girls. Though initially it might be accused of exoticism, through her edit, Tan found a way to countenance the 'tourist gaze'. In *Correction*, she has countenanced the archive of criminal photographs by

subverting the function of the mug shot; confusing the division of prisoners and guards, and reversing in her installation the architectural operation of the panopticon.[37] Considered in this way, Tan's work exemplifies a new direction in critical practice. Where artists in the 1970s such as Allan Sekula or Douglas Huebler had to work hard to deconstruct oppressive forms of organisation and ways of seeing, Tan revisits formerly forbidden practices, never redeeming them casually, nor naively re-accepting them, but thinking again about their facilities as means through which to represent and engage with the world.[38] The move is a brave one, but risks pay off, and the projects are hardly 'doomed to fail'.

Mark Godfrey thanks his MA students at the Slade with whom some of the ideas for this essay were discussed.

[1] The DAAD is an international exchange programme in which artists working in the fields of visual arts, music, literature and the performing arts are invited to spend a year in Berlin.

[2] In his classic text 'The Metropolis and Mental Life' (1903), George Simmel noted the ways in which urban life produced changes in subjectivity. People become more reserved towards each other, and this can develop into 'a slight aversion, a mutual strangeness and repulsion'. 'One nowhere feels as lonely and lost as in the metropolitan crowd.' George Simmel in Charles Harrison and Paul Wood (eds.), *Art in Theory 1900-1990*, Blackwell, Oxford, 1992, pp. 130-135. Tan seems to represent this kind of alienation in Amsterdam in *N.T. Leidsestr* (1997). The artist is shown standing still on the street whilst crowds rush by, sped up in the edit.

[3] August Sander, 'Remarks on My Exhibition at the Cologne Art Union', in *The Weimar Republic Sourcebook*, Anton Kaes, Martin Jay, and Edward Dimendberg eds., University of California Press, Berkeley and Los Angeles, 1994, pp. 645-646

[4] See Blake Stimson, 'The Photographic Comportment of Bernd and Hilla Becher', http://www.tate.org.uk/research/tateresearch/tatepapers/04spring/stimson_paper.htm

[5] See Benjamin Buchloh, 'Thomas Struth's Archive', in *Thomas Struth: Photographs*, The Renaissance Society at the University of Chicago, 1990, and 'Gerhard Richter's *Atlas*: The Anomic Archive', *October* 88, Spring 1999, pp. 117-145

[6] Allan Sekula, 'Reading an Archive', in Brian Wallis (ed.), *Blasted Allegories*, New Museum of Contemporary Art, New York, MIT Press, Cambridge, Mass., 1987, p. 118

[7] Lynne Cooke writes, 'Contrasting types of shots, including the pan and the iris fade, instils a reflexive awareness of the operations of the camera.' See 'Fiona Tan: Re-Take' in *Scenario: Fiona Tan*, Mariska van den Berg and Gabriele Franziska Götz (eds.), vandenberg&wallroth, Amsterdam, 2000, p.22

[8] Ibid., p22

[9] Benjamin Buchloh, 'Portraits/Genre: Thomas Struth' in *Thomas Struth – Portraits*, Schirmer Art Books, Munich, 1997, p. 150

[10] 'In portraiture, a seemingly natural and guaranteed nexus between object and representation had appeared particularly evident: in fact, mimetic resemblance had been one of the category's founding conditions. The desire for the lasting depiction of subjects took the possibilities of physiognomic truth as a natural given, limited, if at all, by the painter's hand, or, conversely, superbly enacted by the painter's mimetic skills.' Benjamin Buchloh, 'Residual Resemblance: Three Notes on the Ends of Portraiture', in *Face-Off*, ICA Philadelphia, 1 994, p. 54

[11] 'We can tell from appearance the work someone does or does not do; we can read in his face whether he is happy or troubled, for life leaves its trail there unavoidably.' August Sander, 'Lecture 5: Photography as a Universal Language', in *Massachusetts Review*, Winter 1978, p. 677

[12] 'It is possible to record the historical physiognomic image of a whole generation and - with enough knowledge of physiognomy - to make that image speak in photographs. The historical image will become even clearer if we join together pictures typical of the many different groups that make up human society.' Ibid., p. 678

[13] Ulrich Keller, 'The Portfolio Arrangement' in *Citizens of the Twentieth Century*, MIT Press, Cambridge, Mass., 1989, p. 37

[14] Alfred Döblin, 'Faces, Images, and Their Truth', reprinted in Susanne Lange, *August Sander*, Taschen, Cologne, 1999, pp. 102-103

[15] Walter Benjamin, 'A Small History of Photography', in *One Way Street*, Verso, London, 1997, p. 252

[16] See also Anne Halley, 'August Sander', *Massachusetts Review*, Winter 1978, pp.668-673

[17] 'Sander's Notary is suffused with self-importance and stiffness, his Usher with assertiveness and brutality; but no notary, no usher could ever have read the signs.' Roland Barthes, *Camera Lucida*, Vintage, London, 1993, p.36

[18] Benjamin Buchloh, 'Portraits/Genre: Thomas Struth' in *Thomas Struth – Portraits*, Schirmer Art Books, Munich, 1997, p.154

[19] Keller, op. cit., p.39

[20] Allan Sekula, 'The Traffic in Photographs', *Art Journal* 41, No. 1, Spring 1981, p. 19. More recent papers that build on or argue against these positions include George Baker, 'Photography between Narrativity and Stasis: August Sander, Degeneration, and the Decay of the Portrait', *October* 76, Spring 1996, pp. 73-113 and Andy Jones, 'Reading August Sander's Archive', *Oxford Art Journal* 23:1, 2000, pp. 1-22

[21] See part III of Benjamin Buchloh, 'Residual Resemblance: Three Notes on the Ends of Portraiture' in *Face-Off*, ICA Philadelphia, 1994

[22] For a full list of the phrases Huebler used, see *Douglas Huebler, Variable etc.*, FRAC Limousin, Limoges, 1993, p. 134-135

[23] Hal Foster, *The Return of the Real*, October books, MIT Press, Cambridge, Mass., 1996, p.196

[24] As Benjamin Buchloh has commented, 'There does not seem to be any room in Struth's middle class compendium for those who have chosen to construct their identities outside of the parameters of a compulsory heterosexuality and its attendant nuclear family formation.' Buchloh, op. cit., p.161

[25] A Google search for 'Thai Brides' hits the website 'mythaibride.com' whose introductory page announces: 'My Thai Bride has been created to help you find what you've always dreamed of and wanted: A beautiful, petite, feminine, affectionate, sexy oriental girl who has a happy and pleasant personality.'

[26] 'The have, literally, dressed-up according to an imagined social scale' comments Graham Clarke in his essay 'Public Faces, Private Lives: August Sander and the Social Typology of the Portrait Photograph' in Graham Clarke (ed.), *The Portrait in Photography*, Reaktion Books, London, 1992, p. 83

[27] Tan filmed more women than men having found out from demographic research that there are more women than men in the city.

[28] Certainly within the art world, post-communist Berlin has accrued a somewhat romanticised reputation as a haven of cheap studios.

[29] According to Starbucks Coffee chairman Howard Schultz, "The early and rapid acceptance of the Starbucks brand in Istanbul has greatly inspired us. Building on the momentum we have achieved in Istanbul, we are very optimistic that our acceptance in Ankara will be no different." http://www.teaandcoffee.net/1104/world.htm

[30] Where Sander's artists occupied a position at the height of his cycle of civilization, Tan explains 'I decided to place artists and other artistic professions in Miscellaneous as I felt that this better fits my reading of their current social position (I am not one for putting artists on a pedestal)'. Email from the artist, February 2005

[31] Roland Barthes, op. cit., p.14

[32] Clarke, op. cit., p. 82. Clarke's essay ends with an account of Sander's *Secretary (Cologne)* (1914) where 'the casual title (*Secretary*) belies the *individual* context.... [A] private, not public, identity inhabits the Sander frame.' p. 93

[33] Of course this phenomenon predates photography. See Harry Berger, *Fictions of the Pose: Rembrandt Against the Italian Renaissance*, Stanford University Press, Stanford, California, 2000

[34] Though Mario Merz does not stay in one place during Tacita Dean's film, it is precisely his minor movements like these that dramatise the work.

[35] In arguing that one of the effects of 16mm film is to underscore the obsolescence of the project, I want to suggest an opposite point. Tan did not use video because by doing so she would have referred to surveillance cameras and to their 'gaze', which is ubiquitous rather than obsolete. She would confront this technology head on in *Correction*.

[36] August Sander, Ibid., p. 678

[37] See the essays gathered in *Fiona Tan: Correction*, MCA Chicago, 2004

[38] Think, for instance, of Matthew Buckingham's deployment of nostalgic found film in *Situation Leading to a Story* (1999) or Marine Hugonnier's treatment of the surveying pan in *Ariana* (2003).

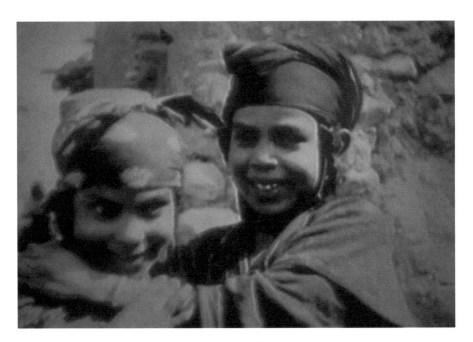

*Facing Forward*, 1999, video still

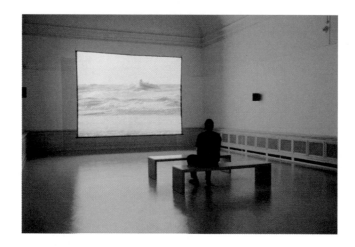

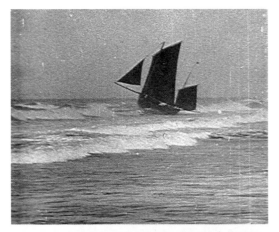

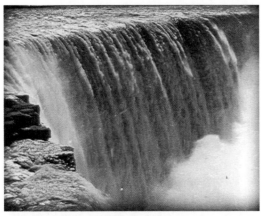

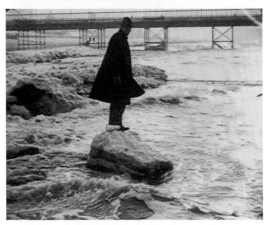

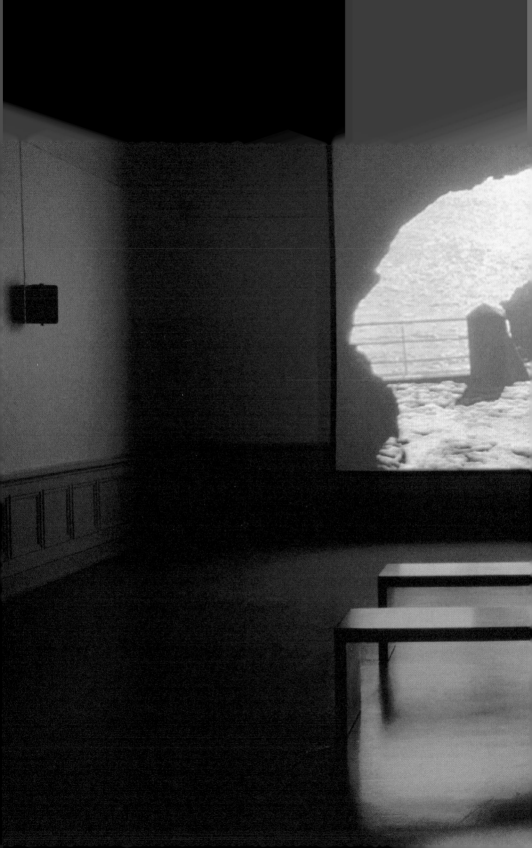

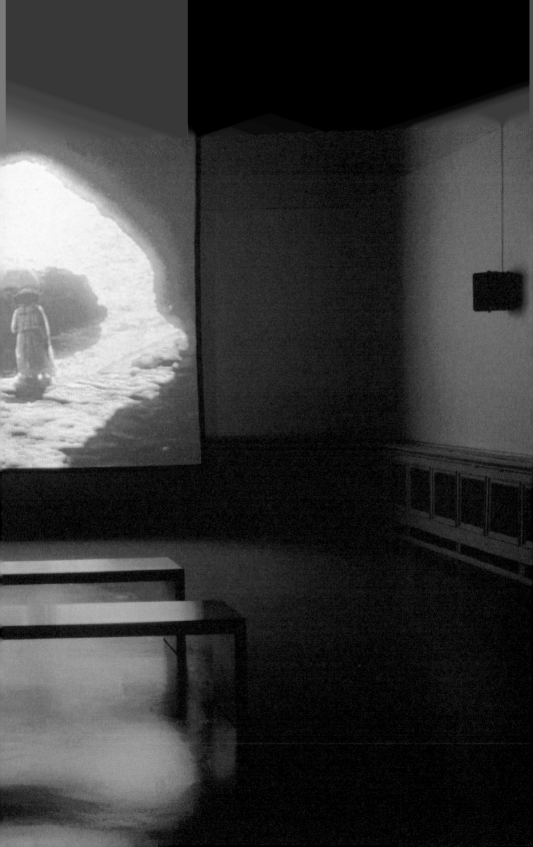

**CORRECTION** 2004

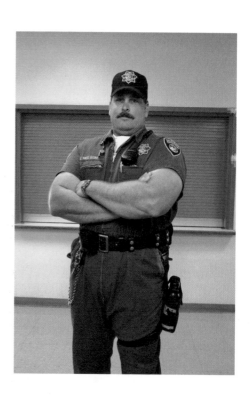

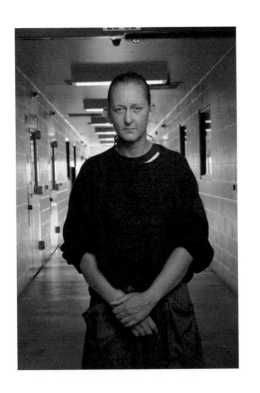
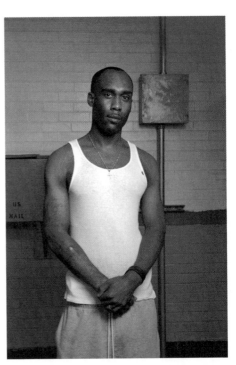

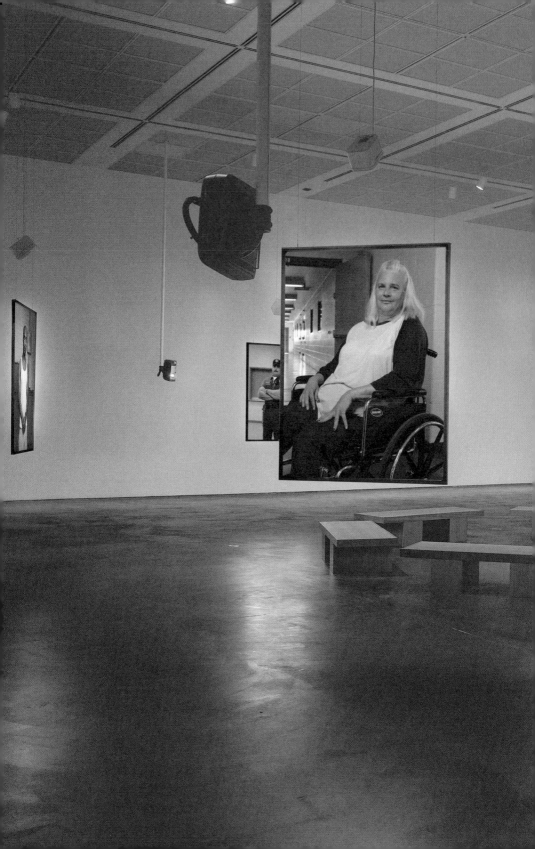

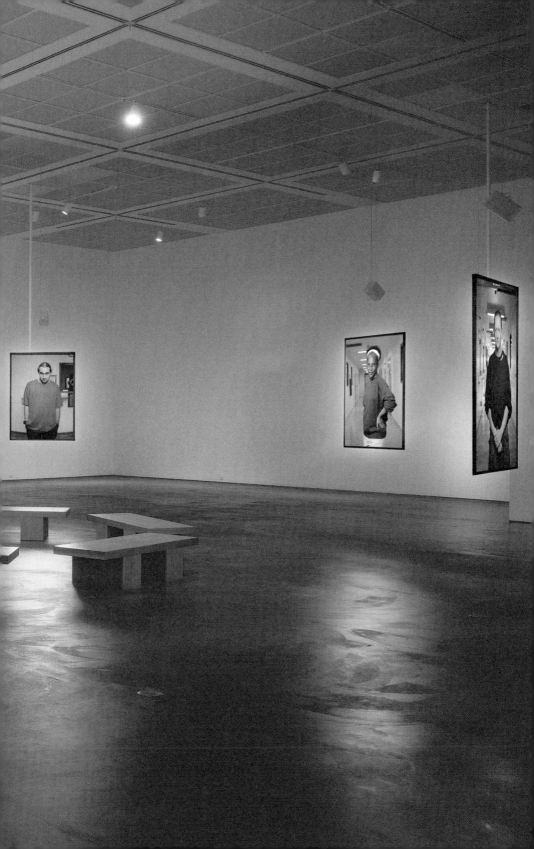

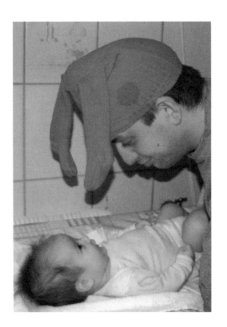

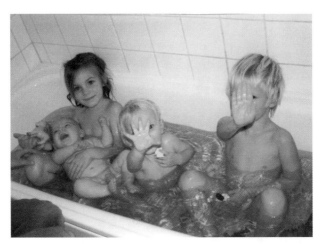

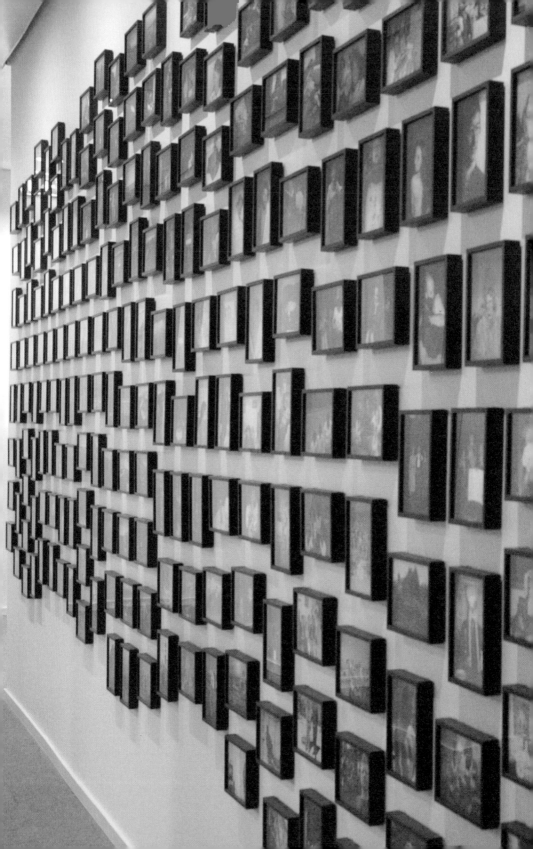

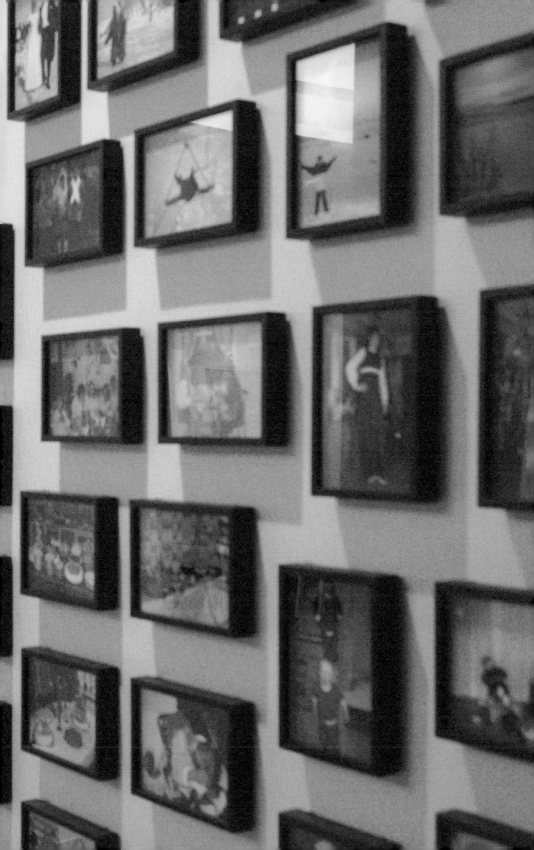

### COUNTENANCE

video installation, 2002
4 video projectors, 4 hifi audio speakers,
room 1: screen - 60 x 44 cm, room 2: 3 translucent
projection screens - 190 x 142 cm

This production was made financially possible by *Documenta 11*;
DAAD, Berliner Künstlerprogramm; Die Photographische Sammlung/SK
Stiftung Kultur, Cologne; Mondriaan Foundation; Film Fund of the
Netherlands; The Netherlands Foundation for Visual Arts, Design
and Architecture

### NEWS FROM THE NEAR FUTURE

video projection, 2003
1 video projector, 1 dvd player, 1 stereo amplifier,
4 stereo hifi speakers
projection size: min. 4 x 3 m

### VOX POPULI

photographic installation, 2004
267 individually framed colour photographs
each 13 x 18 cm

Commissioned by Norwegian Parliament, Oslo

All works courtesy the artist and Frith Street Gallery, London

## FIONA TAN

Born in 1966, Indonesia | Lives and works in Amsterdam
*Education*
1996-97 Rijksakademie van beeldende kunst, Amsterdam
1988-92 Gerrit Rietveld Academie, Amsterdam

### FURTHER READING

John Berger, 'an exchange of letters with Fiona Tan';
Lynne Cook, 'Fiona Tan: Re-take', in *Scenario: Fiona
Tan*, Mariska van den Berg and Gabriele Franziska Götz
(eds.), vandenberg&wallroth, Amsterdam, 2000

Els Hoek, 'Fiona Tan : Preliminary Sketch for an
Eclectic Atlas', *Akte 1*, de Pont Foundation for
Contemporary Art, 2002

Tessa Jackson, 'Reading the Visible and the Invisible',
*Fiona Tan: Correction*, Museum of Contemporary Art,
Chicago, New Museum of Contemporary Art, New
York, Hamer Museum, Los Angeles, 2004

Fiona Tan, 'Open Heart', a correspondance between
Fiona Tan and writer Robert Vernooy, De Balie publishers
Amsterdam, 1998

Fiona Tan, 'Fragments towards a self-portrait of a city
I & II', Hong Kong, RABK, Amsterdam, 1997

Beatrice Von Bismarck, 'Of all the images in the world,
which am I then left with?', *Akte 1*, de Pont Foundation
for Contemporary Art, 2002

Brian Wallis, 'Fiona Tan', *Artes Mundi International Art
Prize*, National Museum and Gallery, Cardiff, 2004

Andrea Wiarda, 'Seeing, Observing, Thinking', *A-Prior:
Fiona Tan*, A-Prior Brussels, 2002

FIONA TAN **COUNTENANCE**

**MODERN ART OXFORD 4 APRIL 2005 – 29 MAY 2005**

Organised by Modern Art Oxford
*Director* ANDREW NAIRNE
*Curator* SUZANNE COTTER
*Assistant Curator* MIRIA SWAIN
*Programme Administrator* DAWN SCARFE
*Gallery Manager* TOM LEGG

*FIONA TAN: COUNTENANCE* has been generously supported by the
Mondrian Foundation, Amsterdam and the Royal Netherlands Embassy, London

With thanks to Livio Comba, Hendrik Driessen, Gabriele Franziska Götz,
Mark Godfrey, Jane Hamlyn, Karon Hepburn, Esther Lampe, Gitta Luiten,
Dale McFarland, Taco de Neef, Charlotte Schepke, Daphne Thissen.

Published by MODERN ART OXFORD
Essay, *Doomed to Fail* by MARK GODFREY
Edited by SUZANNE COTTER, assisted by MIRIA SWAIN
Designed by GABRIELE FRANZISKA GÖTZ
Printed by DRUKKERIJ ROSBEEK BV in an edition of 1000 copies

ISBN: 1 901 352 242
Distributed in the UK by Cornerhouse
70 Oxford Street, Manchester M1 5NH, England
Tel: + 44 (0)161 200 1503
Fax: + 44 (0)161 200 1504
email: publications@cornerhouse.org
www.cornerhouse.org/publications

**MODERN ART OXFORD**
30 Pembroke Street | Oxford OX1 1BP | England
Tel: + 44 (0) 1865 722 733 | Fax: + 44 (0) 1865 722 573
www.modernartoxford.org.uk

MODERN ART OXFORD is supported by Oxford City Council,
Arts Council England, South East, and the Horace W. Goldsmith Foundation.
Museum of Modern Art. Registered charity no. 313035

**MODERN ART OXFORD**     supported by